SING EVERY MORNING

An Inspirational Guide to Take on Your Life's Journey

Gwyneth Moss Bragdon

(Compiled by Jill M. Burrows)

AuthorHouse™
1663 Liberty Drive
Bloomington, IN 47403
www.authorhouse.com
Phone: 1 (800) 839-8640

Published by AuthorHouse 2/10/2016

ISBN: 978-1-5049-7881-1 (sc)
978-1-5049-7882-8 (hc)
978-1-5049-7883-5 (e)

Library of Congress Control Number: 2016902218

Print information available on the last page.

Any people depicted in stock imagery provided by Thinkstock are models,
and such images are being used for illustrative purposes only.
Certain stock imagery © Thinkstock.

This book is printed on acid-free paper.

Because of the dynamic nature of the Internet, any web addresses or links contained in this book may have changed
since publication and may no longer be valid. The views expressed in this work are solely those of the author and do
not necessarily reflect the views of the publisher, and the publisher hereby disclaims any responsibility for them.

author**HOUSE**®

In loving memory of

Gwyneth Moss Bragdon

September 28, 1970–March 9, 2014

It is this celebration of the earth and Life that continues to renew my body and my spirit. It replenishes my belief in the wisdom of positive creation and balanced existence. We must celebrate life like birds; we should sing every morning, if not by mouth then with our hearts and our minds.

—*Gwyneth Bragdon*

Preface

Gwyneth was larger than life. In her final hours and minutes, as her battle-weary body yielded fewer words and instructions, her family and friends still confidently carried out her will without any doubts. And while accurate and true to Gwyneth's intent, these acts were not simply predictable or generic but eccentric, like the person herself. She died at home, donated her remains for scientific research, directed that her cremated body be spread in various meaning-filled corners of the earth, and finally, would likely have preferred that bright garments (like her own) be worn at her memorial. While Gwyneth's voice as we knew it ceases to flow, her choreography continues uninterrupted. To be known by others, you first must know yourself; Gwyneth certainly knew herself, and she guided many others with their own realizations, including her children and her brother. Phenomenal as it is, through her writings, Gwyneth continues to be larger than life.

As her earthly existence faded, there was no pain nor was there any suffering. In the end, Gwyneth asked for only two things: more oxygen and, when this was not enough, her children. When she lay finally in peace, the long, warm, oblique rays of the spring equinox poured into her room and fixed themselves specifically over Gwyneth, uncannily in the exact place where Anais had suggested we put the hospice bed. And so it was that we witnessed Gwyneth's formidable spirit linger and dance among us just as an eagle swoops, glides, and climbs into the evening sky—into the conscience of anyone who dares to dream or simply imagine.

Jeremy Seville Bragdon, Gwyneth's brother

Acknowledgments

I would like to personally thank Gwyneth's care team at Emory University's Winship Cancer Institute in Atlanta, Georgia, as they always remembered to care deeply that a living, breathing person, loved by others, was the recipient of their outstanding and attentive care. Thank you!

In recent weeks, I have attended two important conferences: "Cancer: Innovative Breakthroughs and Personal Journeys" and "Sustaining a Cancer Community in the Era of Personalized Medicine," both sponsored by the Massachusetts General Hospital–Cancer Center. The events, open to the general public, offered glimpses into some of the encouraging advances in immunotherapy as well as other groundbreaking research efforts. The sessions also underscored that there is much hope for these and further advances and for new breakthroughs in cancer care on the near horizon, and I salute Massachusetts General Hospital for their pioneering work and for their efforts to keep the public well informed on all fronts.

In addition to establishing a scholarship fund for Gwyneth's four beloved children, we plan to make contributions from the proceeds of the sale of this book to each of the above institutions.

The cancer conferences I attended also provided some moving personal stories of grateful cancer survivors and their caregivers and the important role of "community" for patients during their cancer journeys. Gwyneth seemed to instinctively know the importance of being upheld by her community of family and friends during her battle with cancer, and she was very fortunate to have been embraced by a very caring community, perhaps in part through her willingness to share illuminating and powerful testimony of her journey on paper.

I would also like to express a heartfelt thank you to Gwyneth's many friends who, moved by her writings (poems, prayers, and meditations), encouraged Gwyneth's family to share the words and wisdom that are found on these pages and that so earnestly speak of Gwyneth's personal life's journey, with the hope that other individuals who struggle with cancer, or other seemingly insurmountable obstacles in life, will find hope, strength, and enlightenment on these pages.

Many thanks to David H. Bragdon, Gwyneth's dad, and to Gwyneth's daughter, Anais Bragdon Ducasse, for the beautiful photos included throughout this book.

But mostly, I would like to thank Gwyneth for her remarkable efforts during a nearly nine-year cancer odyssey to seek and find spiritual balance and health. Although she ultimately did not win her battle with cancer, every day, despite facing monumental odds and uncertainties, she always carried aloft a lamp of hope, faith, and strength as evidence of her abiding love and passion for life. As Gwyneth's mom, I am grateful that through these pages, her voice and spirit will live on.

Jill Burrows

Cambridge, Massachusetts

Introduction

Those who do not know how to weep with their whole heart don't know how to laugh either.

—Golda Meir

Although Gwyneth's writings about her cancer journey are sometimes brought into sharp focus by the urgency of living with debilitating illness, there were aspects of that journey that were not unlike what we each encounter, must grapple with, or give praise to throughout our lives: her search for spiritual balance and wholeness, her love for the people in her life, and an abiding hope for what the future might bring. In this context, Gwyneth's explorations in words become transcendent as she expresses her wonder and joy with life and living. I trust that these words will resonate with anyone who has ever embarked on a cancer journey or is currently experiencing illness or other challenges in life but also that they will be deeply felt and recognized by each of us.

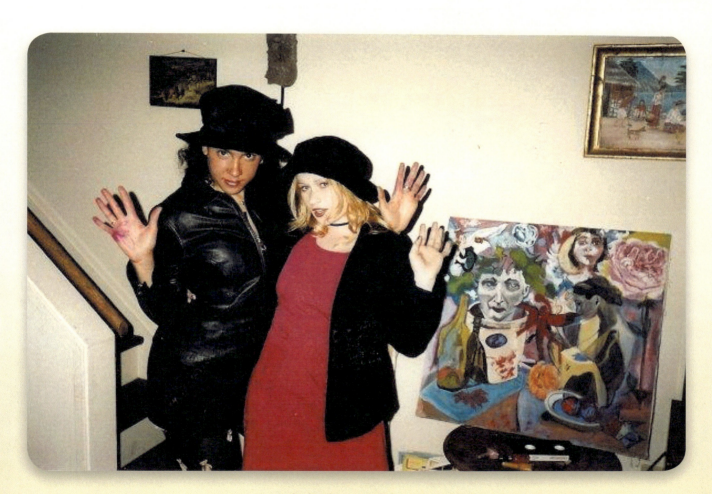

Gwyneth fresh out of the art studio

My Journey Continues

My journey continues …

I feel as good and positive as I have ever felt.

Even when I learned about the "two new small spots" nine months ago, I still felt an overwhelming sense of feeling positive about what can be.

I have the intuition that if I am to survive I have to really love myself, even love a disease of my own body's manifestation.

I am not saying it has been easy, or that there haven't been dark days.

What I am saying is that I now feel a heightened sense of connection with life that I never had before.

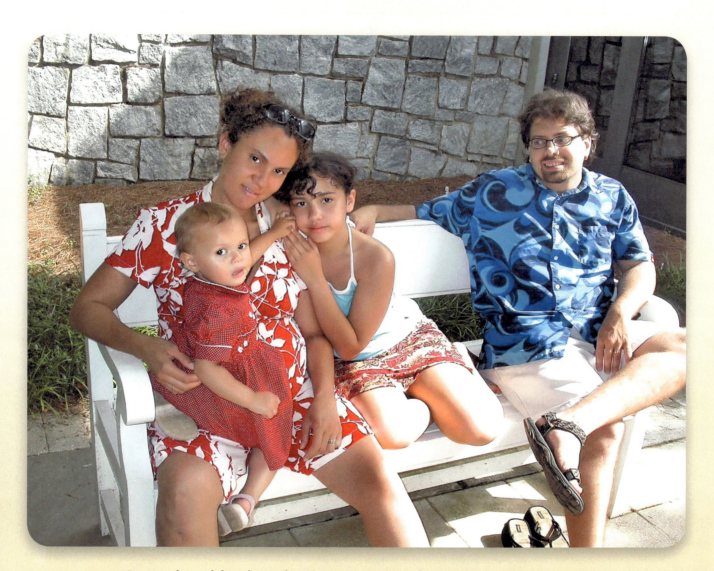

Gwyneth and family at the Carter Center, Atlanta, Georgia, May 2004

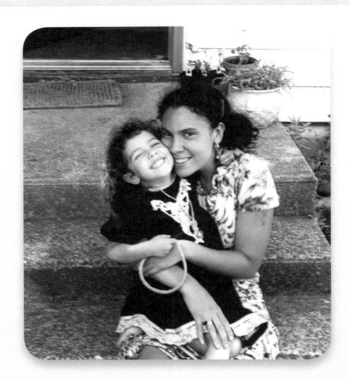

These Were the Last Words I Spoke to My Mom

My beautiful mother. You are my backbone. My biggest critic and my number one fan. You've always believed in me, and I can't express to you how much you have inspired me to never give up on myself. Honestly, you are the world to me and I don't know how I'm going to function without you, but I'll do my best for you. You've helped make me a stronger person. My best friend!

I'm so proud to be able to call you my mother.

Your loving daughter, Anais, March 10, 2014

The Job of a Mom

The job of a mom
is to make her children
feel right, and good.

You make me
feel right,
you make me
feel good.

You are a true mom.

Cyrus, age 9

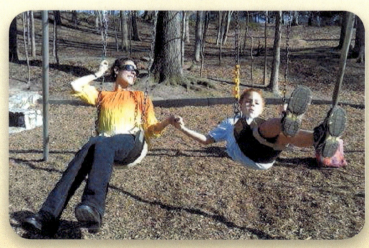

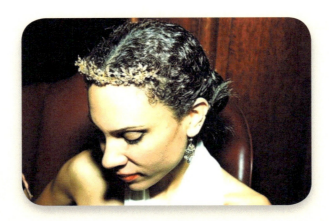

September 28, 2014

Dearest Gwyneth,

Today we are celebrating what would have been your forty-fourth birthday! This letter is not the birthday celebration we would have planned, but I want you to know that you continue to illumine our lives and to deepen our own experience and embrace of life. You showed us by example that, even in today's complex world, it is possible to lead a life of deep faith and spirituality. We have so many joyful memories of your prodigious gifts of mind and spirit that you portrayed in poignant word and in breathtaking roles in theater and dance productions, as well as your illuminating presence on the stage of Life itself. You consistently chose creative expression as a vehicle for finding the meaning behind the meaning of things—an honest response to your unflinching desire to know the truth, wherever it led, and to freely express what you felt and saw using your fertile gifts of mind and spirit. We acknowledge with great admiration your difficult, but heroic, tango with debilitating illness that, try as it might, could *not* suppress your vibrant spirit nor ravage your physical beauty or inner light; nor deter your ever deepening love for your children and for life itself.

Love you, Mom

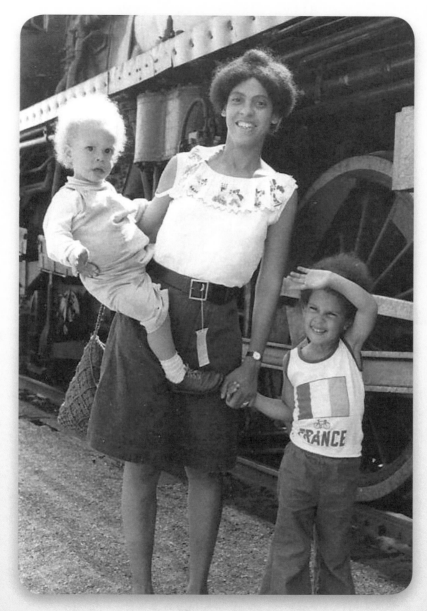

At Steamtown in Vermont, July 14, 1974, Jeremy and Gwyneth with their mom, Jill

In Her Words

Let Me Smile at the Possibilities Before Me

About three months ago, when I first rested my right palm on my once-soft tummy and the inner surface of my hand hit something hard, I thought, *Something is terribly wrong.*

For five days I kept the secret to myself, too afraid to tell a soul. I thought perhaps it would just go away, like all the other fears about my body I had ever had. I worked in Gaia Garden, picked sweet peas, and dug in the ground to unearth the first harvest of potatoes. They were white, purple, and blue nested in the earth; we broke them free. Daniel the farmer was very particular about how I picked the sweet peas. He said they had to be very fat—the fatter they are, the sweeter they are—and I suppose that is the point. I worked hard that day, but my energy was low, and the heat of the sun was reaching a point where the exhaustion of my body was imminent. In a rush I had left without water, and I regretted it. I wondered at the low feeling of my energy and thought it must have to do

with the mass in my abdomen. I thought, *I am going to die*, and I had never felt so close to the earth before in my life, surrounded by that garden.

In order to do my job correctly, I discovered I had to crouch down and gaze up through the sweet pea vines in order for the fat peas to be revealed. (I thought, *Better not disappoint Daniel, and besides it's better to do every job well if one is going to do it*—another example of my need for perfection. I thought that if I picked a pea that was too skinny, I would be failing.) Otherwise the glare of the sun was too much, and the excessive brightness from above deceived the eye to the full fatness possibility of the individual pea. However, from below, the slant of shade revealed the plumpness of each jam-packed pea. I tasted the peas as I went along, as was instructed of me, to be part of understanding the process and yes, experience is the key to full understanding in life. The fat peas are sweeter and result in a much more complete involvement with the taste buds.

How much I loved the earth that day—before and today too, but that day I could feel her breath inside my body and my body inside of her. I thought, *I am going to die, just like the cycles of this garden I too shall have mine, and this is life. This is life.*

I wish all humans could feel that. If we could, we would care about our planet, comprehend the true meaning of the moment—every moment—and love ourselves and each other more than ever before. Relish every moment, relish each other, mean what you say, embrace every hug, say I love you like you may die that day.

I cried in between the peas, quietly. I wept for myself, for my children, for the earth, for life itself. And they were beautiful tears—warm like the sun—and there was light in my heart even if I felt heavy. My body was so alive; I had a rhythm to understand. This life moves so quickly. Slow down to hear what it says, for answers to your questions lie in the stillness of air between your breaths.

Now I release my pain back to the earth, to the sky. Let the wind carry my blood to the tops of trees, and let me smile at the possibilities before me.

I Am

For once, instead of trying to be who I think I am, I have actually become who I am—like a lotus flower opening, like fish that run themselves on shore and open their gills to oxygenated air and then relinquish their beautiful, rotting fish flesh to the elements, their minerals seeping into the vast ecosystems of our planet, leaving tiny rainbows in the sand. Like deer that leap and run through bramble thickets, apples that fall from trees and no one hears, a child who cries with needs, the lines in the face of weathered wisdom gives the experience of knowledge to light; circular motion, cycles, the rhythm and course of oceans and salt, skies and wind, earth and soil. *I am.*

My Small Planet

On my small planet it has been eight years now that I have walked a spider-fine line between life and death. Death! So many view it as something far off on the horizon. For me, it has become a window from which I gaze at earth. Or is it the other way around? Which side am I on? What is this lesson? No time to wonder for too long. I must focus, focus, focus on the children—they are like great mountains of ancient gemstones holding me here. Their light is like a magnificent garden of endless opportunity. So, it is love that conquers death!

I Wept in Gratitude for the Lessons Yet to Be Uncovered

On September 28, I celebrated my thirty-seventh birthday. It felt very emotional leading up to the special day. I was struggling somewhere internally with the fact that I was still here and remembering everything that I and my family and friends have been through to get me to this day. I thought about my parents and my brother and how this whole journey must have been for them. They have never been far from my side, unfaltering pillars of strength. I meditated about my children and how much they inspire me every day to find my true self and unknown stores of strength.

I wept for friends, neighbors, and strangers who have supported me and shown me the true potential of human faithfulness. I wept for the beauty of other young adults who have become my friends, who have lived, *are* living, with cancer, and who reached out for my hand and captured my heart and soul without ever hesitating as we walked through fire together. Our souls are so familiar, I sometimes wonder if we have journeyed here together from some common planet.

I wept for myself; for friends I thought were friends but who disappeared when the going got tough; for acquaintances who surprised me and became some of my closest allies; and for all those who remained as unmovable rocks through it all as I struggled with the realities of the surgeries and the chemo, of the needles, and the experience of being brought to the brink of death and back.

But I wept mostly with such deep gratitude for that fragile membrane between life and death we all walk along in this life, for the earth, for everything precious, for everything cruel, and for the cycles of life and the lessons yet to be uncovered.

Sing Every Morning

Nourishing food is spiritual sustenance! I hold it in my hands; in my mouth it is like holy nectar, it is vital, it is close to the earth, and it brings me closer to her. Just as the birds celebrate the rising of the sun, so do I celebrate the closeness of my diet to the earth—nutrition so simple and so powerfully fed by that sun.

It is this celebration of the earth and life that continues to renew my body and my spirit. It replenishes my belief in the wisdom of positive creation and balanced existence. We must celebrate life like these birds: we should sing every morning, if not by mouth then with our hearts and our minds. We should shine like the bald head on a serene and powerful young woman with the smile of a thousand suns.

We should taste our food straight from the earth and place our heads and hands beyond the blankets of concrete that bedspread so much of this globe to the mind's eye, a point of existence that brings connection, life, and light to all beings under the setting and rising sun.

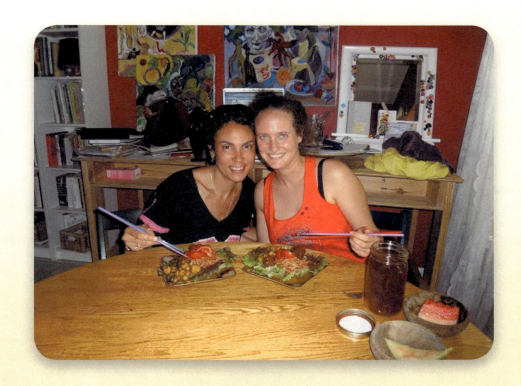

Some Were Beaten Down and Dejected, Some Laughed

Yesterday, I saw myself in other people—some in pain, and some in peace—all along their own journeys of self-discovery, rising above the foul and the fear. Lounge chairs were placed in rows; no one closed their curtains. We sat each of us on a chair; nurses came and plugged us into IV lines, bags dripped their fluids down through those tubes, entering our bodies connected through these holes in our chests. Some bags held the blood of others, bodily fluids from a secret donor; other bags hold the cytotoxic fluids of chemo. Nurses wore vinyl blue coverings that swooshed in the wind as they walked, and they donned double blue gloves of protection. One old man had to have a shot in the stomach to boost his blood count; he willingly opened his shirt and bared his naked abdomen for application. He had a tumor in his spine, he said. Radiation therapy, he said. He looked both sad and emotionless at the same time. He was pale and read a book; I wondered about his life and why he was alone. Others were bald—some bared their shiny bald heads for all to see, others wrapped their heads in colorful turbans or scarves, and some wore wigs. Many people laughed and faced their situations with tenacity—they were old hat at this, I could tell. Others were beaten down and dejected; their heads hung down low like weights. Faced with the possibility of death, we all come and go from this place.

Let My Heart Discover Its Wings

Who are you, but essence wrapped
between two stars.

I imagine a heart like two red blankets
Folded, and beating … My own heart
Caught on a pointed skewer;
My body already dust
Blown against a branch.

And yet I am alive,
Discovering, burrowing.

My disguise, a hand searching,
Struggling, trying to stroke
What is beyond.

The love of God is great.
Let me not define the
Separation then.
Let my heart discover its wings
That formed as if from nothing,
But from before.

Time is moving forward.
Can you not discern its message?
Like a rainbow, I am gone.

Enjoy Tonight's Sunset!

Today, I enjoyed a beautiful pink and purple sunset. Just now, the sky turned to a dull purple color, and soon it will be nightfall. The sky has turned forbidding now: huge, dark purple clouds are blowing across the sky. So powerful! Even more powerful than a pitch black sky! I don't know the scientific explanation for sunsets, but I know they are wondrous. They really make you wonder about life and our existence.

Although sunsets are the most beautiful part of the day, they only last for a short time.

Mother Teresa and Sun Hats

Thank you, everyone, for your love and support! It really makes me feel I can cross the finish line when I have people cheering for me. I stare at the sun's reflections on the leaves of the trees since I cannot go in the sun. I had been thinking about how I was going to walk through the woods here and use cancer as a good teacher—to do the things I wouldn't have done otherwise in life. To walk the road less traveled. As life has me quite a bit slowed down, I am taking the time to read and think most deeply about life and how beautiful it is and to study Saint Teresa and all the people who have done such great deeds in life.

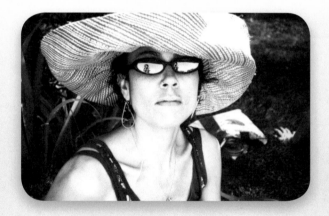

When I was in Europe, I met Dr. Ray, Director of Clinical Chemistry at the Royal Hobart Hospital, on the bus en route to the train, when I first landed in Frankfurt. Just before I left for Europe, the thought had occurred to me that I would like to study Mother Teresa, and so I ordered a book about her before I left Atlanta. It arrived two days before my departure, and just two days later I was meeting one of Mother Teresa's main doctors on the empty bus to Terminal Two. Dr. Ray ran one of Mother T's hospitals in Africa. He is a pathologist, like my brother, and is in the process of opening a preventative wellness center in Australia. He had a photo of Yogananda in his briefcase, and, it so happened, I was carrying a little book of Yogananda's, *Scientific Healing Affirmations*. Dr. Ray kissed me in the middle of my forehead and asked me if I knew why we had met just then on the bus. Without hesitating, I said *yes*!

My Faith Lights Every Dark Corner

Well, things aren't always easy, but my faith in God fills every crack, lights every dark corner, and nourishes my *soul*.

The last line of a note from Gwyneth on Dec. 5, 2011

Photo taken on Sunday, October 11, 2009, near Harvard, Massachusetts

The Horse Is Still Beneath Me

(Excerpt from a letter to a friend, January 2007)

Fear and disillusionment had crept into my soul, and I was riding it like an angry horse. I wanted off so badly. I tried, but I couldn't seem to dismount.

While I was in the hospital, I had a really bad night where I felt I had slipped into the pit of hell. All of a sudden I was surrounded by a forest of trees, and down into the pit they threw vines and leafy branches. Without hesitation I reached up and grabbed on so tightly to those life lines that Nature pulled me up and out of the pit. I felt heartfelt peace and was able to finally drift off to sleep.

A week ago, we drove up into the mountains. There I was living the vision that had so boldly embraced me from beyond. I rolled down the window and cried to the trees, "I love you, trees!" with tears running down my face. I was home; the sound of rushing water fell down mountain rocks, wet soil, and fallen branches. Something has shifted; the horse is still beneath me, but we are running together.

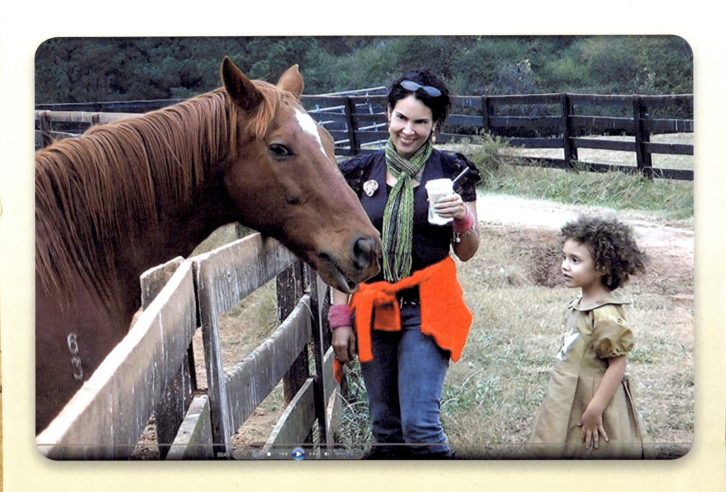

The Meaning of Life (2007)

Let me tell you a secret. The answer is in a field, in the grass, on the slope of a mountain, in the sound of streams and rivers, in the bottom of the ocean, in the changing of the sky, in the universe, in the smell of rotting leaves, and in the simplicity of a vein that travels your body and also travels to the edge of a leaf.

Among the Chaos, There Are Miracles

I sometimes experience fear and panic in the middle of the night. Suddenly awake at 2:00 a.m., I wonder, *Am I breathing?* Within the panicked spiral of those middle-of-the-night executions and the feeling that all hope is lost, a strong and gentle voice comes suddenly, saying, "Within the presence of this great universe, miracles are more than possible, Gwyneth." This was the beginning of the sweet nectar that then flowed from somewhere above and into my body. Something changed right then and there, a shift up and over a great cliff, a green valley on the other side.

A Light in the Darkness

It is my children, the love that surrounds me, and God moving me spiritually that keep the glow of vitality and life force in my breath and body. I have seen five people—four in my community alone—die of cancer before me. Some were my supporters. How lucky I am to still be here like this, filled with the grace of God, a light in the darkness.

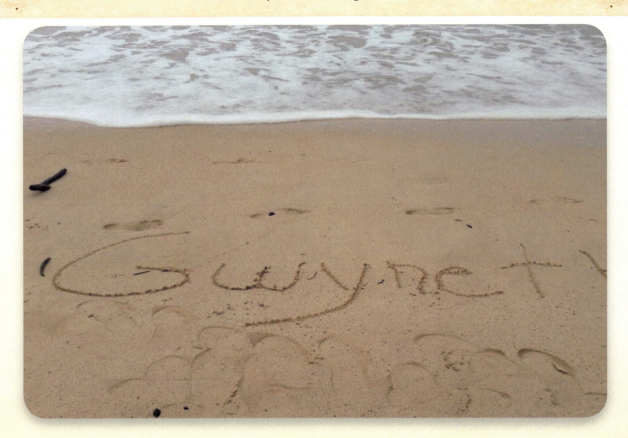

Blog One

I am writing this blog early in the morning of June 15, 2007. This time of year the birds start chirping at 4:30 a.m.; they sense the rising of the sun one hour before it starts to peek above the horizon, and they celebrate. It is round two of my 5FU chemo infusions while pregnant, and I hear the sound of the birds and I try to celebrate with them. I close my eyes and picture the sun rising up above the edge of the earth. A symphony of nature calls to it: "We hear you, we feel you, we rejoice." There is reliability in this; and there is saneness in this mad world.

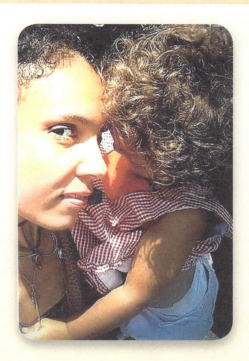

Patience

Patience is the jewel in the crown of
Unfulfillment.
Oh my heart do not forsake me now!
Let me be strong in the face of longing,
And peaceful in the midst of tumultuous life.
Let me trust in knowing everything will
Work itself out.
Let my face show nothing but joy, and
Let my heart know only love!

Letter from Gwyneth on Her Birthday

October 2, 2013

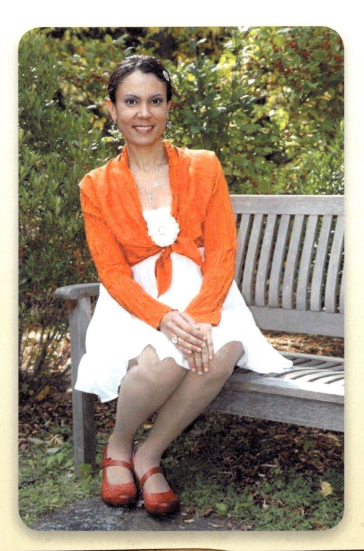

Decatur was so thoughtful to reschedule the rained-out Fourth of July fireworks on my birthday! So I brought in my new birth year with big bangs of light following a dinner of South Indian delicacies, rich curry, stuffed dosas, spicy sambar, and mango lassi.

Then, driving home, I decided to take a back road, where I came upon a little bunny hopping down the street as fast as it could go. To my amazement it was not deterred by my passing in a large metal box, nor did it seem to think it at all strange to be on pavement. Instead it kept its focus straight ahead and went as quick as lightning into the moonlight. I translated this experience into "Keep celebrating and focusing straight ahead with fertile ideas, children and family and those friends who bring healthy life."

Reading each of your birthday wishes was like opening tiny presents filled with such large love, light, and beautiful grace. You are each a part of me, and I of you. Thank you!

Let Me Introduce Myself

(Excerpts from a letter)

I would love to take this opportunity to formally introduce myself.

I am a mother of four, an artist, a community builder, a believer, and so much more than I can comprehend, as is true for us all.

My father gave me my earthly name of Gwyneth, which is a Welsh name that means "white mists rising," "lady of the new vision," and "wife of Merlin."

I honor aspects of all religion and believe in the one thread of universal truth. If I am thrown into the water, I swim rather than struggle to get out.

I no longer have my full head of curly hair. Leading up to the day I shaved my own head, I had the experience of losing my hair in the shower in clumps for days due to chemotherapy.

I am thirty-seven years old, and the loss of my hair of course was a reminder of my fragile mortality that is encompassed in my struggle to regain wholeness. I want to stress I have so much to be thankful for, and I live in gratitude—but I have also suffered through countless procedures, scans, and manipulations of my physical body that have brought me to the darkest places of anguish. I have said good-bye to some of my body parts along with tumor burden, my sigmoid colon, and half of my precious liver.

I was so weak I could not even walk, and when finally I did, I stooped like an old lady. More recently I have also lost my taste buds and have not tasted food in months; I almost live on love and air. I open my veins once every two weeks to toxic chemicals and my psyche to the suffering of other human beings worse off than I.

Not only have I experienced the loss of these things, but I also face the loss of my entire body and, much more importantly, the chance to support my children on their life journeys.

A shaved head you should wear comfortably on your shoulders as you walk your path—like a cancer patient who sheds their hair and limbs without damage to their ultimate being.

To describe my spiritual path visually, I would say it would be colorful and have stretches of long white glittery passageways and landscapes. I want to not only feel unity but also live as much as humanly possible in that unity—I believe this is what is meant when they speak about living in the moment, which is all we truly have. The future is now.

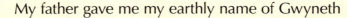

My father gave me my earthly name of Gwyneth

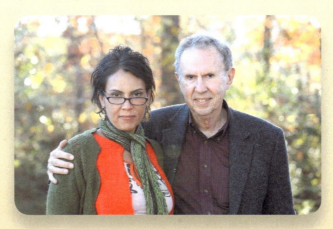

Love in the Cancer Center

(From Gwyneth's Cancer Blog, December 13, 2012)

At the cancer center, people living on the edge of life and death *love* each other … like the couple over there nestled side by side. He has a white beard (like Santa Claus) that reaches down his upper torso, and his left arm is gently but firmly around her. She is fast asleep on top of the beard-blanketed chest, and this supports him while he rests his head on her head on his body. Soundlessly they sit, but the love that pours between them reaches magnitudes immeasurable. When another couple arrives they take a seat across from me and stun me with their splendor. Her dark, chocolate-brown head needs no bejeweled crown for it is shiny on its own; baldness reveals only perfection. Beneath a pinnacled orb, delicate ears turn gracefully upward like an elf's, and her eyes are set perfectly like two almond jewels. Her husband is handsome, European, and he is feeling so happy. Their love spreads to me like a vine of fruit, producing smiles, and while harvesting giggles, I am stirred to turn left where a majestically humble and dreadlocked Rastafarian is praying, hands pressed together. His eyes are closed and yet I feel they see; in this instant we realize together there is no death where life lives! And so, we come to pray together. Now there are four smiles and soundlessly loud and joined internal voices—connecting, collectively glowing, with indisputable love knowing that one God with light lives inside us.

I Love the Ocean, She Said

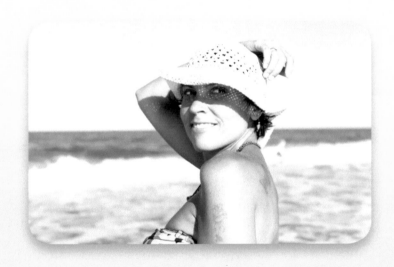

The sun drips
Its vital essence
Pounding against walls:
Heartbeats and smiles;
A tremor
Stirs like the lightest dust
Shaking itself from inside
To meet me outside …
Like the gentle tickle of feathers.
Real breath sparks the imagination
With warmth, like fireflies,
And carries me to where sand
And sun meet to greet the ocean,
And the sky widens
Like your heart.

I Shall Dance

This is me: I'm part bird, part animal, and I can see myself suspended and then moving through time—connected with light through sky, mountains, river, and all of eternity, for my body will turn back to dust, my eternal soul will rise, and I shall dance!

Grape Juice Communion

A few weeks ago in the cancer center, a young girl who couldn't have been more than fifteen sat in the chair next to me with her mother. At one point I overheard the girl's mother say, "She's my only child." The mother was stoic sitting there next to her young daughter—bald, beautiful, and pale, her freckles spotted across her delicate nose like feathers under her translucent skin. As her last bag grew dry she became freezing cold, shivering and asking for blanket after blanket. The nurses piled them high, but she still shivered, and she could not breathe very well, so they brought in a breathing machine and held the mask flush against her skin. She was frightened, her eyes rolling back in her head. She cried in pain. She was feisty but told the male nurse kindly, "It isn't your fault" when he said, "I'm sorry, baby," in his Southern drawl.

Earlier I had found out that I could have communion served to me right in the chemotherapy bay! So a few hours later a young female Episcopal priest appeared, bringing me communion in a small, portable kit. There she stood with a smile, holding a Bible and a black box containing plastic covered cups of grape juice and wafers, the flesh of Christ. She apologized for the tackiness of the portable kit, but with a sense of humor we laughed. She pulled up a chair, and soon we were speaking closely about life, death, and living a spiritual path. I admit I felt a bit self-conscious sharing intimate details about my inner life with Jesus there in the chemo bay. Even there, where Christ is most present among the sick and suffering, I wondered, *Am I offending anyone around me?*

But still, I spoke truthfully from my heart, where it is nestled deeply in my innermost self, there where my faith gave me strength as I sat in the chair receiving another's blood. I admit I was so scared that day, so physically weak, needing the help of others—not just imagining or intellectualizing but living the real frailness of life, vulnerable and naked. "Naked I came from my mother's womb; naked I will return there. The LORD has given; the LORD has taken; bless the LORD's name." Then the priest consecrated the Holy Communion, we said the Lord's Prayer together, and then she handed me the body of Christ and the little plastic cup of grape juice wine, the blood of Christ. These things had been made holy by way of prayer, by way of intention, by the way our hearts bled together with love.

Behind us hung the bag of red blood that dripped the brightest, deepest red imaginable into my veins. My veins were like a highway for life force, bringing me the hemoglobin carrying the oxygen—what a gift! The color of the grape juice deepened next to the bag of gelatinous blood. The blood of Christ brightened my spiritual life, fortified my trust in God, and the blood from the IV strengthened my physical life. Both, intertwining, became one at the altar we had created with our intent—where two or more are gathered there is Christ, opening the gates for grace, bringing the spirit world into the earth, and in that moment the young fifteen-year-old girl sat with her eyes shut. I thought of her at the moment the grape juice crossed the threshold, tossing over my tongue, the best-tasting grape juice melting the wafer in my mouth, and it was complete sustenance.

What Is Bravery?

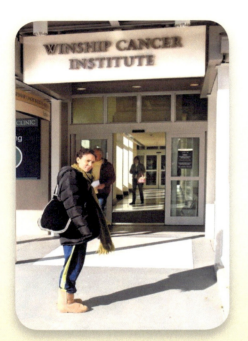

I find it so difficult to go to the cancer center these days. I cry in the car all the way there, feeling sorry for myself—yes, in a sense—but crying mostly for the baby. I want to run from anything that might cause harm or suffering to this child but needing to trust in the power of survival and the ability of the body to rebalance itself in the continual miracle of life. I also weep for the strange-seeming cruelness of the world, everything that makes you ask why. The waiting rooms are packed with cancer patients; there are so many of them, and I ask why. A young woman is there this time; she can't be much older than my eldest daughter, Anais—fifteen or so. She is so beautiful, so calm; she stands and sits so straight, her spinal column extended, her shoulders down, her head shiny and bald, small and perfectly round, balanced pleasantly on top. Her eyes are big, bright, and gentle; she smiles at everyone; with such a bright smile she could light up the room like a light bulb. I marvel at her, at her strength, at her beauty, at her calmness, at her self-assuredness. I want to kneel in front of her and tell her how beautiful she is, how proud I am of her, but I am too exhausted to move, too chicken to speak the truth because I feel I will invade her space with my heartfelt emotions. I want to ask her how she does it, so young and looking more powerful than almost any adult. Her inner light is lit so bright, I swear she is an angel. Later, when I enter the Infusion Center, I see her sitting in a chair with her shirt pulled up, and they are taking huge tubes of blood from her stomach. I feel sick and can't look; I want to cry again at the absurdity. But she sits there still straight, calm, assured, and shiny, like Joan of Arc, like a heavenly being, an archangel!

You Are a Star!

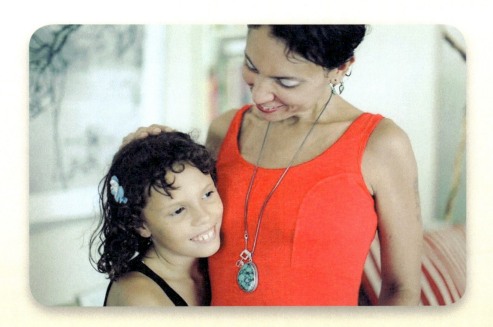

Dust flies and the pollen swims through the Southern night sky—then, descending, lands back on earth, where it settles on everything it touches: park benches, abandoned decks, green leaves, brown leaves, sidewalks, and the parked cars where children run their fingers in the thick, yellow powder, scratching images of letters of the alphabet and games of tic tac toe. "Come play with me," calls springtime as it triumphs over winter once again. Eventually hard rains will fall; nature runs in rivulets down side streets, carrying the pollen, which stains the water, until eventually it disappears, turning into other things like the stars that begin their lives as clouds of dust and gas called nebulae. Imploding, the stars became us, every single atom in your body, the calcium in your bones, the carbon in your genes, the iron in your blood. We are a walking galaxy of fossil stardust. You are connected. You are a star

I Can Feel the Loving Spirit of You All!

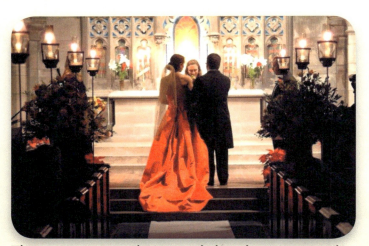

Yesterday, before my first round of chemotherapy, I awakened from a dream. In the dream I was receiving a chemo treatment, and it was working. The sensation of a warm liquid coursing through my veins was not unpleasant; I lay in my dream world and watched the process unfold throughout my body. In my dream navigation, I saw the chemo coursing through my arteries and veins, and in my mind's eye I found my liver.

The tumors were drying and shrunken; I opened my liver up like a loaf of bread and plucked out those shriveled tumors like mold or clumps of flour. I was methodical, concentrated, and calm; I plucked until I found every last one and pulled them from their fleshy nest. Then I squeezed, almost hugged with my hands, my liver back into place and put it back in my body. The primary tumor in my colon I cut out with a gold knife. I closed my body back up and woke up.

That morning of chemo I awoke to angels, those of the human kind: flowers and love notes and chalk messages written on my front sidewalk, messages of encouragement and endearment: "We are with you every step of the way," "We love you," "If you need us, call us!" Lavender plants to absorb toxins from the air arrived in pots, along with spiritual videos. My children were looked after and cared for, a delicious nourishing meal awaited when I got home, candles were lit later in the evening, and e-mails and phone calls arrived. I have become Spirit, and *I feel the spirit of you all.*

I Do Not Want to Bloom Alone

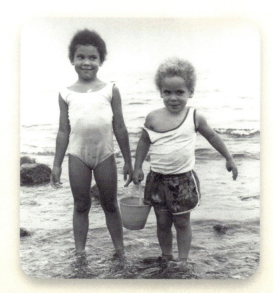

Love clings to the rapture love brings. I do not want to bloom alone, for then I would be only half a flower, just suspended in a rain shower.

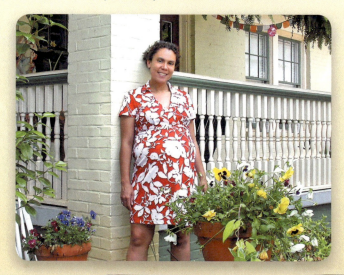

Say Yes!

Yes, we are each small on the face of the planet, but we can be big in other people's lives.

It is our relationship with the world that brings us pain or pleasure, as if life were a silent picture, and our movements tell the story.

Prayer Poem

The more I prayed,
The closer I came to God.
Who can really truly know themselves,
Unless they come so close to God,
They melt in ecstasy.

Letter One from Gwyneth Following Her Initial Diagnosis of Stage 4 Cancer

Dear Family and Friends,

I know you have been waiting for the latest word and information on how I am doing and what is going on. You have been patient, you have been more than helpful, you have been my team, and I have come to understand beyond words how very lucky I am to be me, to have such amazing people in my life.

If I could express to you in words what it is like to have cancer, I would tell you I have left this world as I have known it and am now on some strange planet. I am in a science fiction novel, where I leave sunlight to enter halls of bright lights and uniformed beings who draw my blood and implant devices under my skin. I wake up on tables, where machines bleep and beings with masks and netted surgical hats smile down at me. I am happy to see them when I open my eyes—I don't know them and may never see them again—but they mean I am still alive, I think.

As I emerge from the daze of a happy anesthetic cocktail, I chirp happily to them. They have asked me questions about who I am. I love the ocean, I tell them. I lived in Oregon once, I tell them, where it rains; it is so green there, did you know that? The experience is as if awaking from a dream. This is all a dream, I think, all a dream, and I can wake up after all. I share small, intimate vignettes with strangers and realize slowly that this is no dream.

I was supposed to be born in Boston, but I was a month late, my parents tell me. Much as my life is today, I find myself in cities but dream of the countryside. I have early memories of childhood, earlier than I am supposed to. I remember running through long fields and climbing on rocks. I remember

picking wild blueberries and loving so deep in my heart the deer that came to graze at the edge of our field—wild and unkempt, it was—and as a little girl I was in heaven with this earth.

This planet seems so different. Next Thursday they will draw blood samples from the port embedded deep in my sub clavicle vein, and toxic substances from a plastic bag will be emptied down through that surgically implanted hole. I will open my body—relinquish my body and not my soul—to oh holy and hellish liquid of damage in hopes that those cells that have decided to become renegades and that have decided their existence is more important than the life of my body, and my love for my children, will be more damaged in the end than the rest. I will walk through fire to see my children at the end of this dark and eerie tunnel. If my skin is scorched and my mouth full of sores, oh children whose bright smiles and the curious ways with which you make me learn, I will make it through to you. We'll eat wild blueberries together.

I still believe in the power of nature and the energy of this universe, in the stars I always wondered at, and the clouds that puff by in smoky leisure—even storms that ravage lands, uproot trees, and plunge the ocean deep into the folds of earth's safe secrets. Still, no matter what, don't hate this world. It isn't all dark now, is it? If I could, I would tell you about how strangers have touched my life and changed it forever for the better. One anesthesiologist found me after a procedure in the recovery room and knelt down on the floor, head at my knees, my hands grasped in his. "No matter what happens," he said, "remember life is good."

May Creativity Be Your Freedom

I do see that much is fertile for you as if your senses are awakening from an ancient soil from your past, and your ancestors all live and breathe in you, and you can choose what you want to foster. May all things that are sprouting be fruitful, may the soil be your anchor, your heart a garden, and creativity your freedom.

A Prescription for Life

The meaning of life is quite simple, and it is up to each of us to find it.

No matter where you are and what your outlook is, the ultimate goal is to find compassion. Start with compassion for yourself so that you can love. When you can love, then you can love life, and you can love others.

The meaning of life is also to find balance, to look at both sides. Then, it is to be able to find an avenue to travel on—whether it is paved, or flowered, or set in stone.

Find out who your inner child is, and let it live. Remember what made you happiest when you were young and cultivate that garden.

And never forget to dream!

Afterword

During my final trip to see Gwyneth, I was looking through early scrapbooks with her daughter, Anais. I came across a photo of Gwyneth curled up and asleep on a Greyhound bus (presumably composed and gifted to her by a stranger and fellow traveler). Gwyneth's fragility as a young woman traveling fearlessly, partly driven by curiosity for a world outside her own and perhaps partly fleeing the same, showed through with devastating clarity. Perhaps I was witnessing a chink in her tough, big sister armor? In that photo, rays of sun pierced through the bus window and embraced my sister, safely carrying her into a new day. So she would stubbornly pioneer her way into another day on the frontier. Looking at that picture, I felt her fear, her fragility, her strength, her loneliness, her presence—I felt it all. I gazed for a long time, my mind lost in those contrasting imperatives of the spirit. Little Anais's gaze was fixed on me, and her penetrating dark brown eyes were saying, like that horse in Robert Frost's poem, "Why do you stop and linger here?" And then the little girl, my sister's little girl, was asking, "Why are you crying, Uncle?" Turning the page in the scrapbook, I returned my bittersweet rumination back to whence it had come—some cultures call that place the heart, others the brain, still others the gut; it is all that and more. I composed myself and said only, "It's nothing, Anais. I must be tired from traveling." But in those thoughts, the tired traveler was, in fact, Gwyneth, running to but also from. She was my Hamlet, who pondered so much about that "undiscovered country" and who weighed those "ills we have" against those "we know not of." Leave it to my sister, I suppose. She has left the former and traveled to the latter. After eight and one half heroic years with her improbable battle against late-stage colon cancer—all that she learned, all that she endured and experienced—where has she gone? It was the day we set our clocks ahead an hour; it was the day after a passenger jet bound from Malaysia to China went missing over the vast blue sea. Yes, that is where I think Gwyneth has embarked to; she is in that imperceptible hinterland, hopefully helping to guide every passenger safely home to their loved ones. But if not, she has gone to guide them to that undiscovered country.

Jeremy Seville Bragdon, March 9, 2014

About the Author

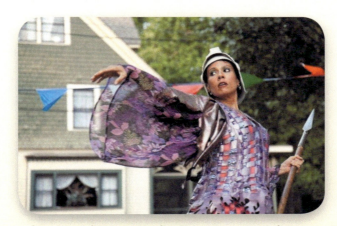

Gwyneth Moss Bragdon, dancer, choreographer, actress, teaching artist, experiential anatomy practitioner, was born in Peterborough, New Hampshire, and lived much of her young life in Acton, Massachusetts. She began her formal study of dance at age five with Carol Sumner of the New York City Ballet and later earned a Bachelor of Dance Arts degree with a minor in dance and music ethnology from the University of Michigan (Ann Arbor). While at U of M, she was one of the artists invited to join professors, psychologists, and social workers in a research think tank—in collaboration with American writer and philosopher Ken Wilber—that focused on transpersonal psychology. Gwyneth performed leading roles as an actor/dancer throughout the Northwestern United States in productions such as *Macbeth* (directed by Peter Anthony), *Hair,* and *Rashomon.* She also performed and choreographed plays and performance pieces internationally for a Canadian Fringe Festival. As an instructor and teaching artist, Gwyneth taught dance for preschool through university levels and found working with "non-dancers" particularly rewarding. She also led workshops in creative movement and experiential anatomy, facilitating sacred space for personal discovery. When Gwyneth moved to Atlanta, Georgia, she was honored to serve as an Artistic Associate (2006–2012) at Gateway Performance Productions, where she was the first to portray the lead role of Hypatia of

Alexandria as well as provide choreography for *Remembering Hypatia* (a play by Sandra Hughes). For Gateway's production of *Water is Life: Hidden Springs, Atlanta* (commissioned by Art on the Atlanta Beltline), Gwyneth was a featured dancer and choreographer. She was also instrumental in the development of new performance pieces such as *Amazon Dances*, which was performed and choreographed with Allen Pittman for a Gateway Community Arts Barter event. Gwyneth was extensively involved in community organization and facilitation and was a trained and award-winning community facilitator through the Neighborhood Foundation for Atlanta, United Way. Her most important role in life, however, was being the mother of her four beloved children: Anais, Gillian, Cyrus, and Leaf.

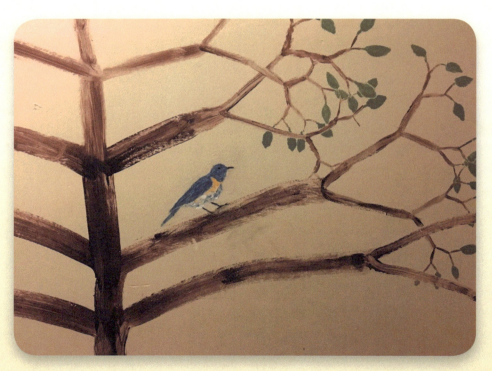

The Bluebird of Happiness. Gwyneth's family completed special "Bluebird" murals in honor of Gwyneth, who, as she battled with cancer, came to be affectionately known as the Bluebird Warrior by her friends and family. The bluebird, as a symbol of happiness, is found in many cultures, including

that of Native American tribes. One of the oldest references to the bluebird of happiness may be found in Chinese literature from the Shang dynasty, 1766–1122 BCE. The Navajo use a bluebird song to remind tribe members to wake at dawn and rise to greet the sun. In the 1908 story of the "Bluebird of Happiness," a fairy sends the children of a woodcutter to look for the Bluebird of Happiness in distant lands. The children return empty handed, only to find that the bird is safe at home. The moral of the story is perhaps that true happiness can be found within!

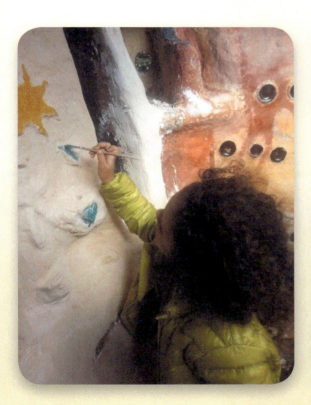
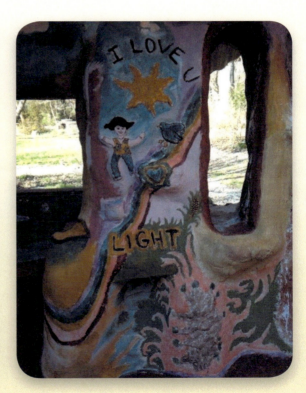

Printed in the United States
By Bookmasters